FROM **rain** TO *rainbows*

FROM **rain** TO *rainbows*

CHRONICLE BOOKS

SAN FRANCISCO

Pages 118–119 constitute a continuation of the
copyright page.

Library of Congress Cataloging-in-Publication
Data available.

ISBN: 978-1-4521-3505-2

Manufactured in China.
Design by Mia Johnson
Cover illustration by
Blanca Gómez

Back cover illustrations by Jen Stark, Mr. Boddington's Studio, Jay Fleck, Ana
Bidart, Samantha Hahn, Annette Mangseth, Florence Boudet, Miss Peden,
Jamie Shelman, Catherina Türk, Irène Sneddon, TRACCIAMENTI

10 9 8 7 6 5 4 3 2 1

Chronicle Books LLC
680 Second Street
San Francisco, CA 94107
www.chroniclebooks.com

They say it's always darkest before the dawn.

They say that which does not kill you makes you stronger.

They say without the rain you'd never see the rainbow.

Well, they say a lot of things, actually.

Here's what they don't say so much: That both rain and rainbows can make you happy if you let them. That to cheer yourself up, sometimes all you need to do is get out of yourself for a moment. Not chastise yourself for your poor attitude, but simply give yourself—or let someone else give you—a gentle little nudge in the direction of gladness.

Is the first half of this book—full of rain and rainclouds and puddles and gray skies—sad, and the second half—full of sunbeams and rainbows and unicorns—happy? Come on, is anything that simple? No. Maybe you are a person who loves the rain; maybe you jumped in puddles as a kid and sneaked out to dance in downpours as a teenager. Or maybe you see things a bit more classically; maybe to you, dark weather does suggest sorrow, and a rainbow our hope of relief from sorrow.

It doesn't matter. Whatever your personal associations with these images, this book is saying the same basic two things to you.

One: Nothing stays the same forever. Life is a progression. There are good parts and bad parts, dreamy parts and silly parts, tragedies and healing, crummy days and fabulous days, rain and rainbows. Whatever is hurting us will someday come to an end. And that is a solace. But you know what? Whatever is making us gleeful will also

someday come to an end. And that's a consolation of a different kind—the kind that reminds you to perk up and pay attention, to cherish both the sound of the rain on the roof and the arc of color in the sky that catches you utterly by surprise, because both will be gone before you know it.

And, two: When someone creates something, that creation is a gift. The artists whose work is featured in this book have made these images as gifts for you, whether they knew that's what they were doing or not. It's a common misconception that art has to be hard—that the more people a work of art confuses or shuts out, the better it is. We say: Let the artist bring gladness to the viewer if that's what the artist wants to do. The viewer just has to be ready to receive the gift.

Both the fruits of human creativity and the wonders of nature have this in common: we possess the astonishing ability to take them in through our senses and let them nourish our souls. Art can be the nudge we need to move away from the endless circling of our own thoughts, to move toward an outlook that's just a little bit brighter.

To move from rain to rainbows.

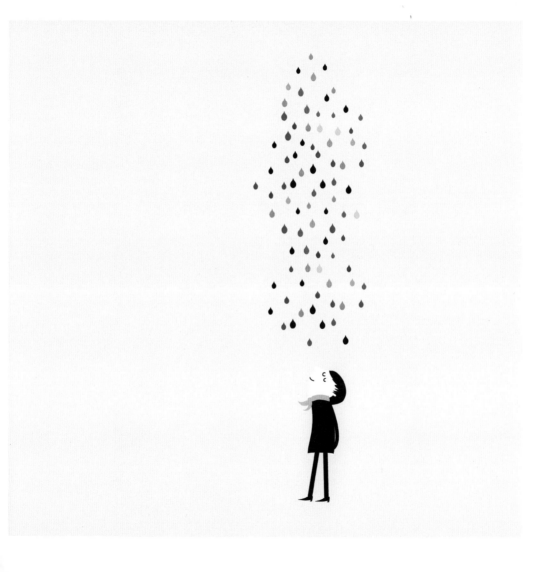

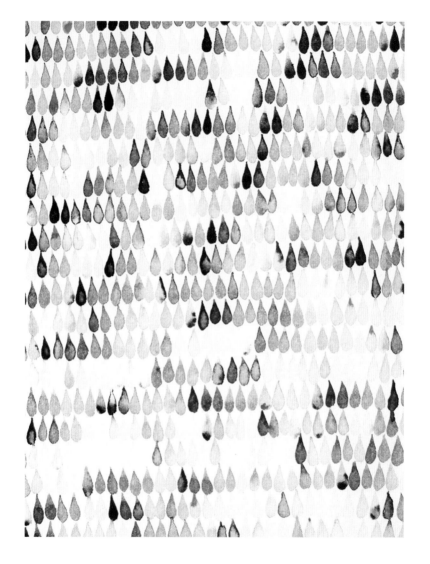

this drawing of an umbrella
will not keep you dry.

marc johns

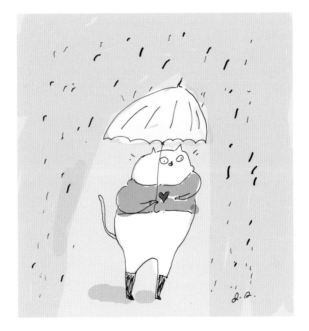

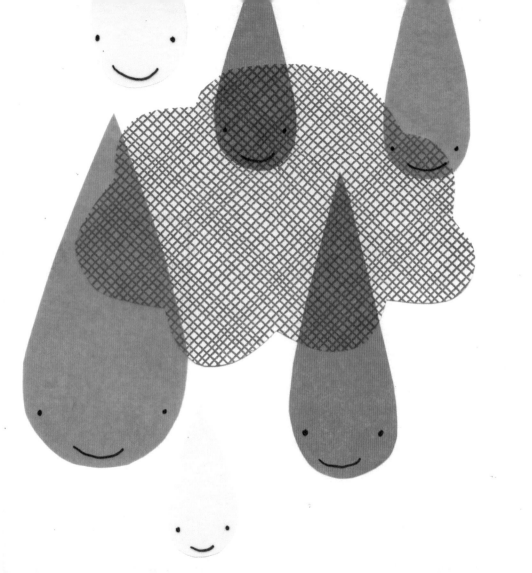

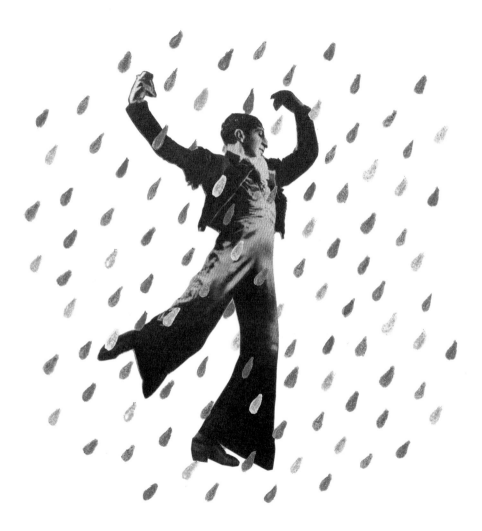

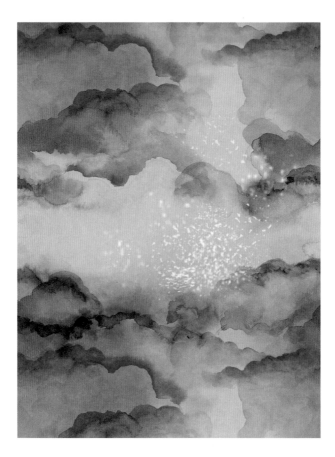

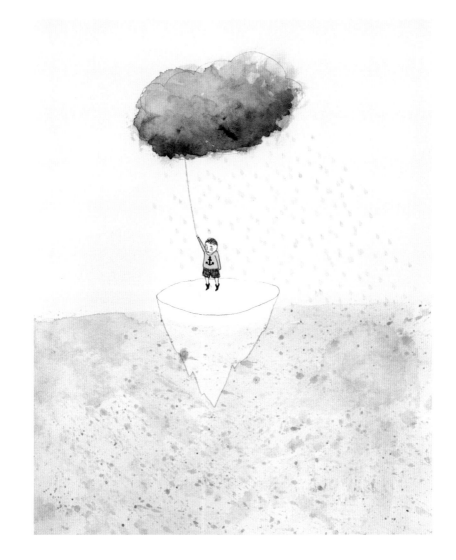

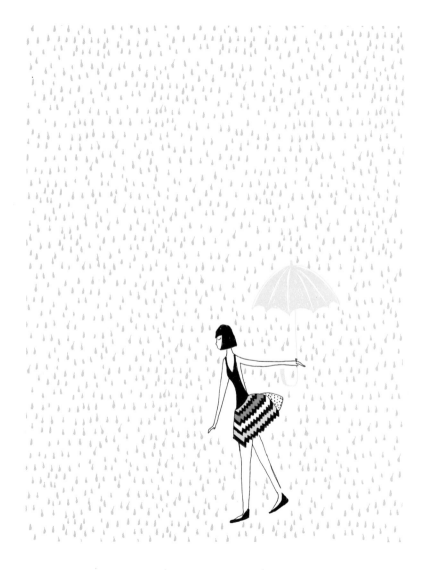

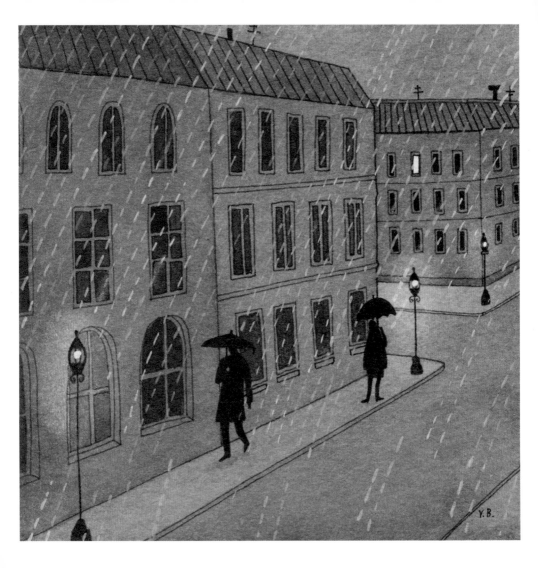

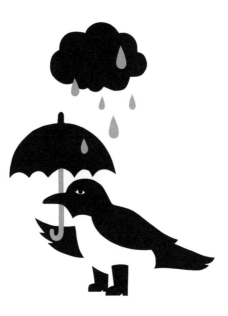

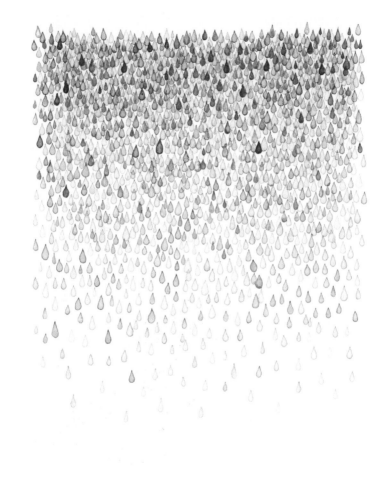

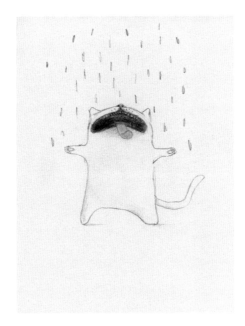

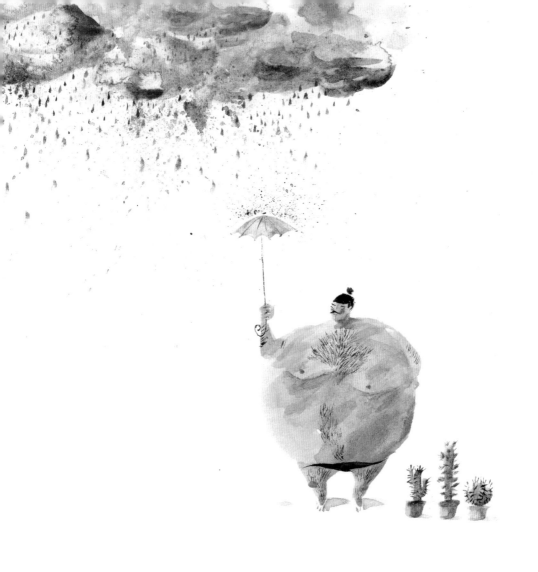

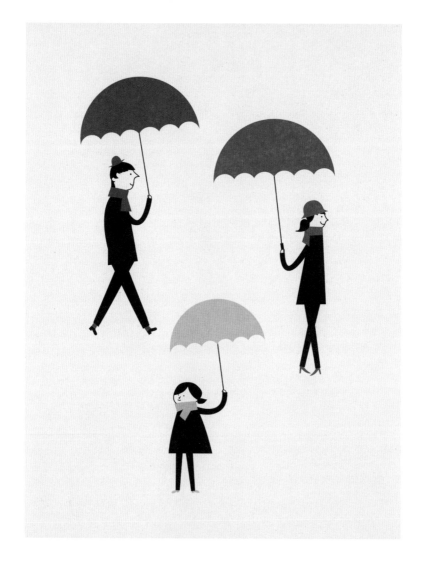

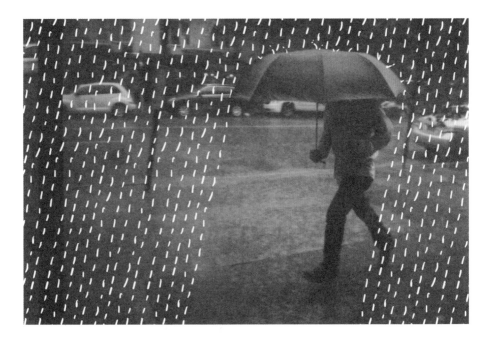

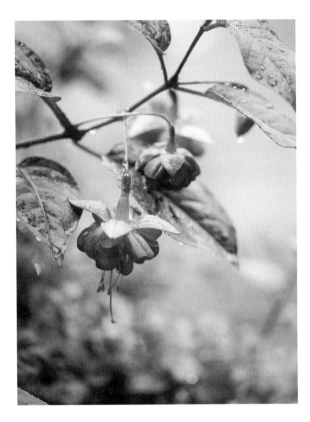

yael 2010

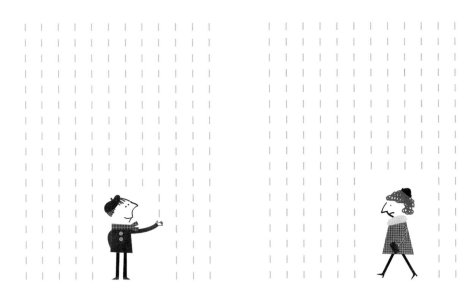

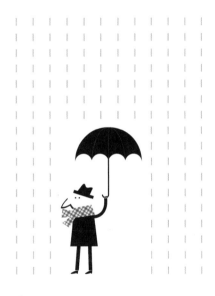

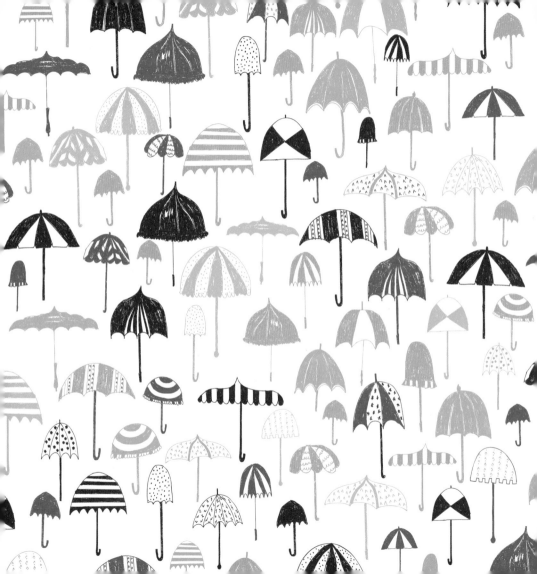

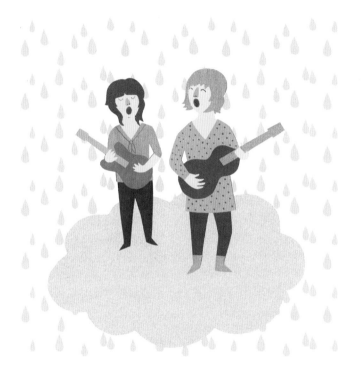

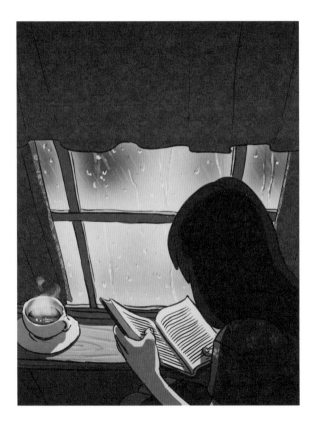

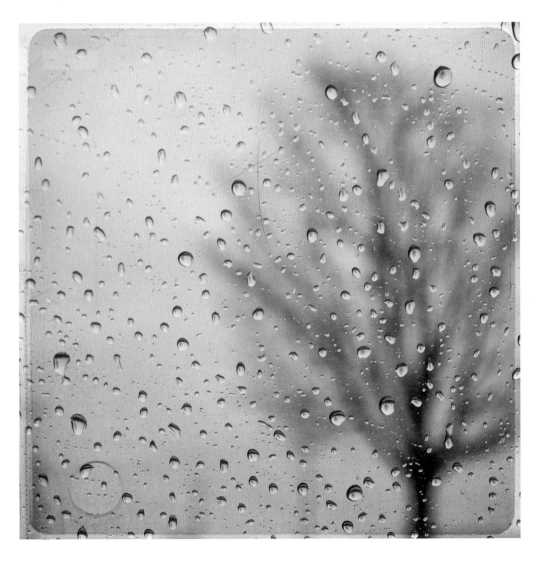

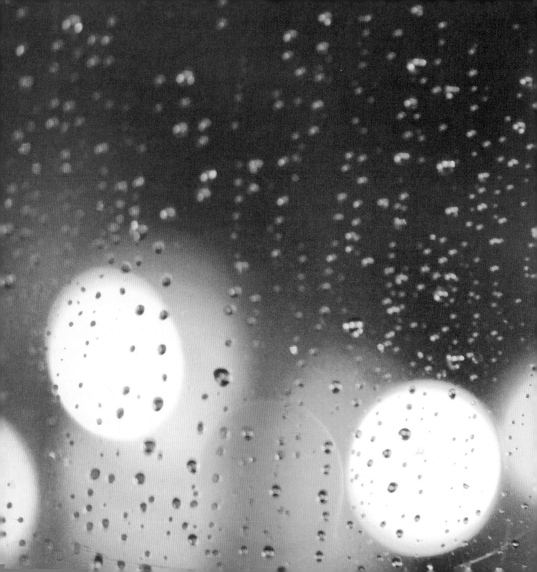

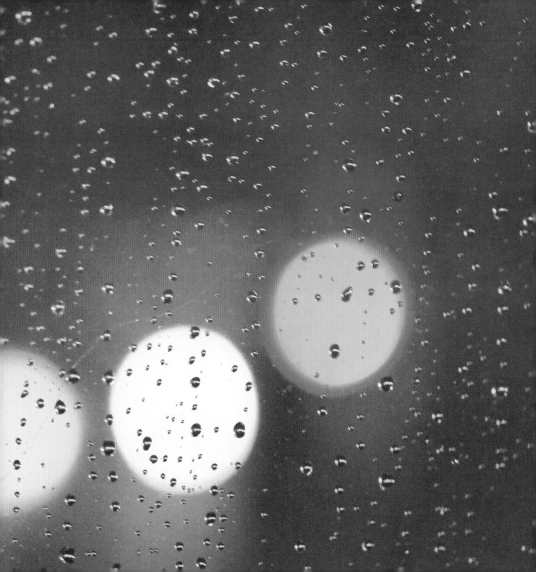

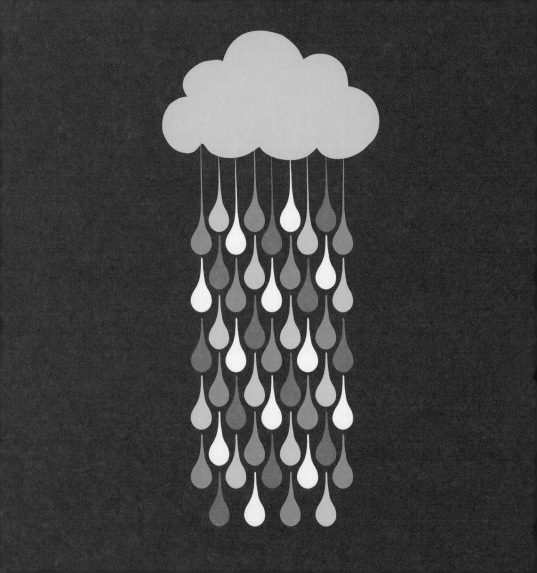

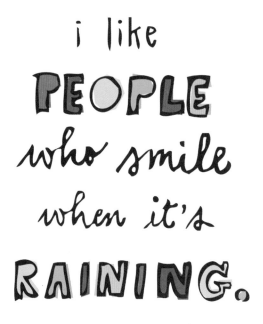

i like
PEOPLE
who smile
when it's
RAINING.

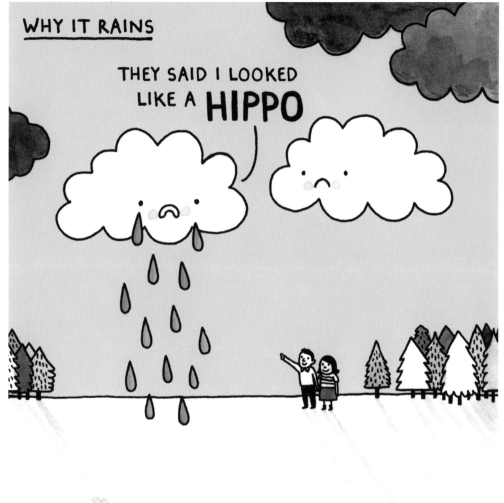

AFTER RAIN
COMES THE RAINBOW

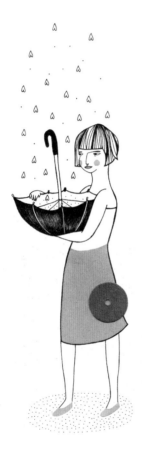

Avril Loreti | Modern Home

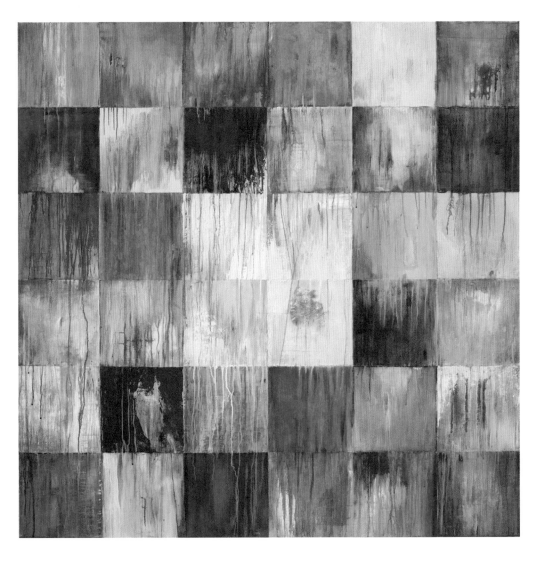

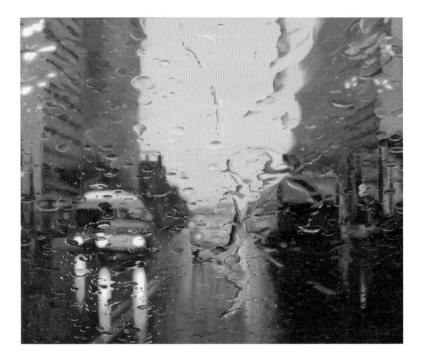

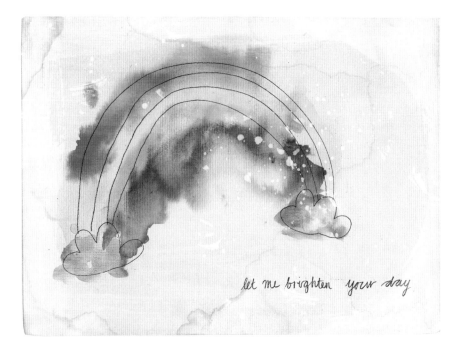

let me brighten your day

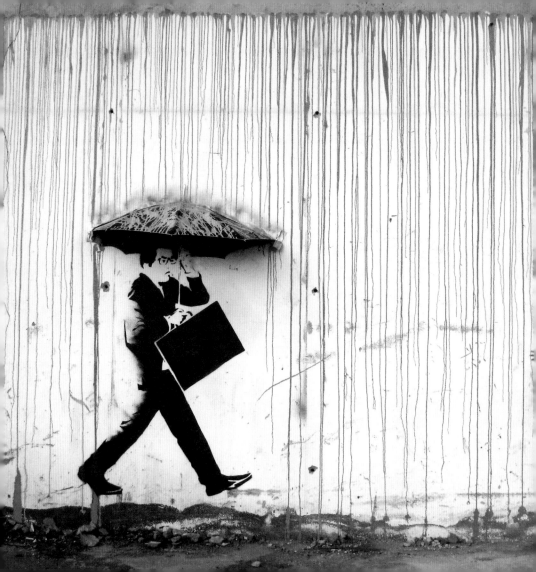

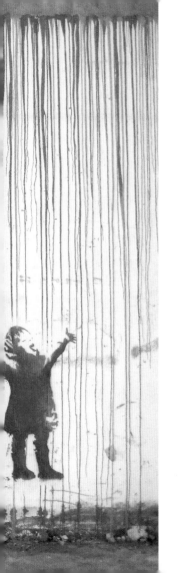

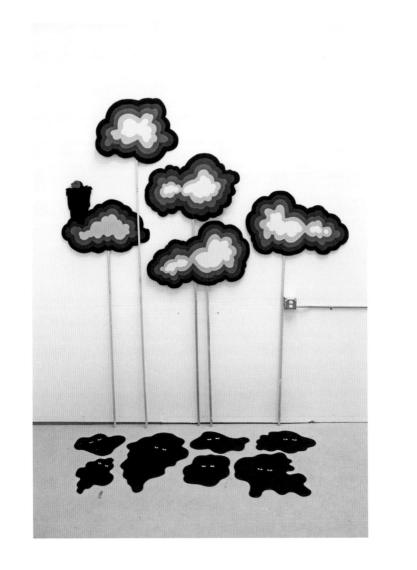

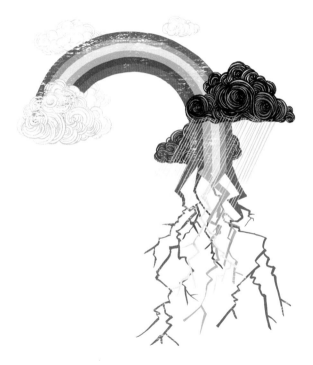

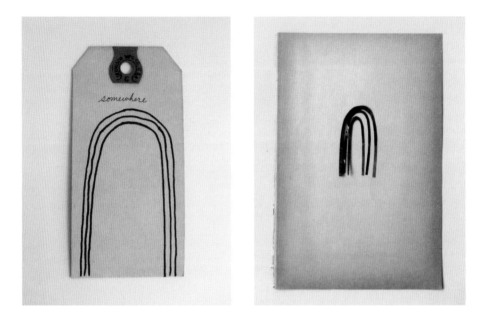

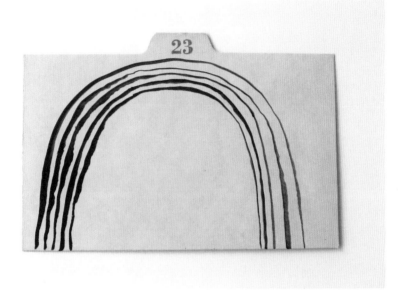

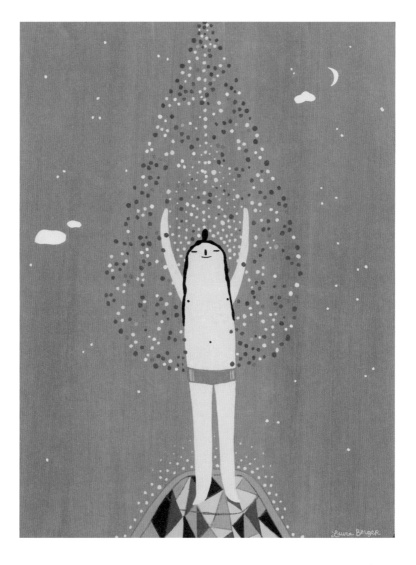

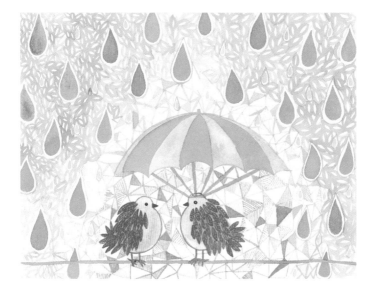

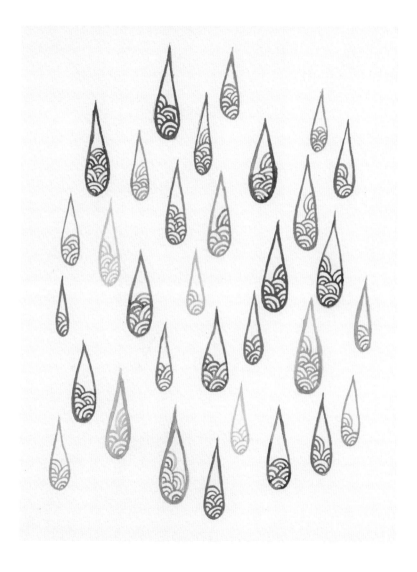

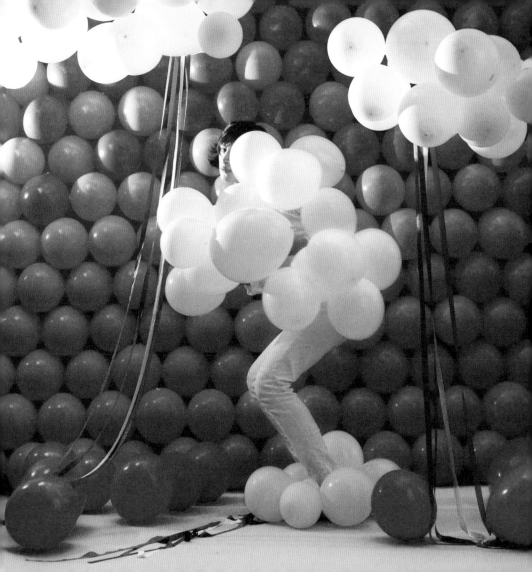

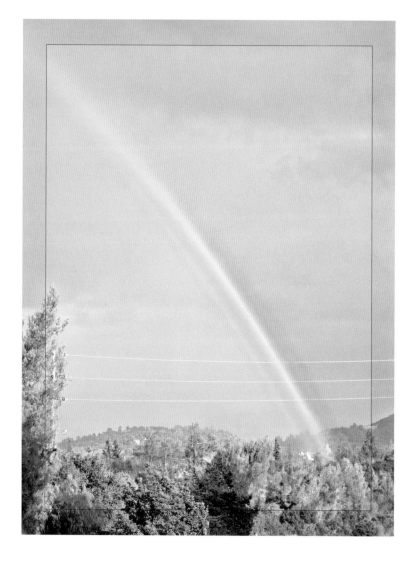

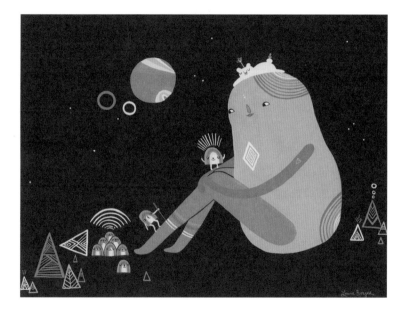

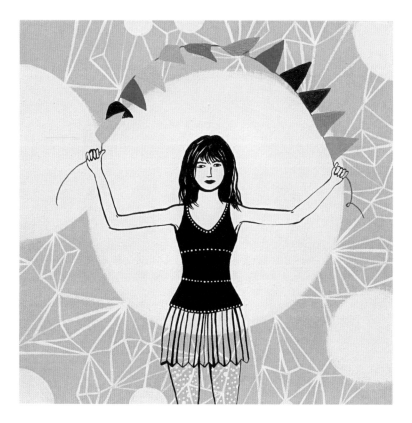

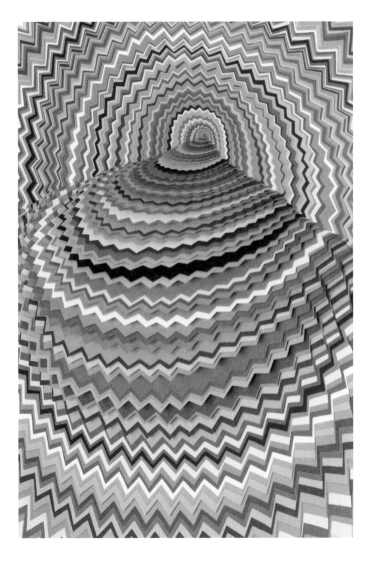

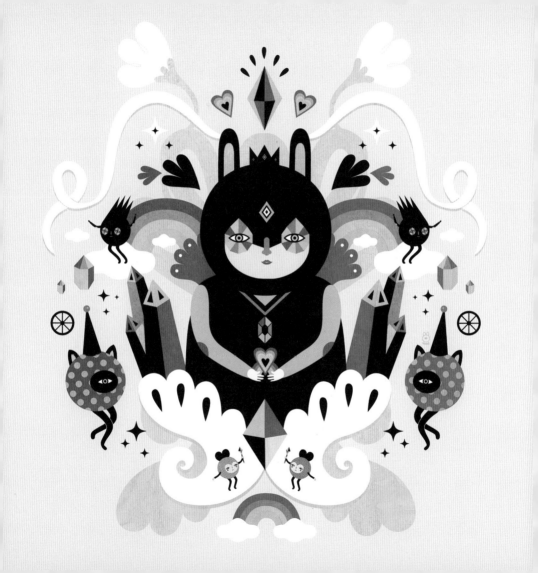

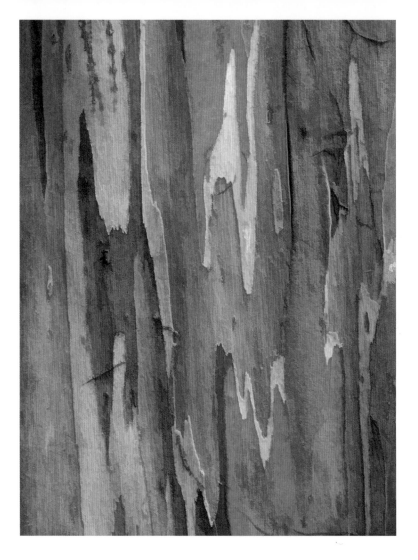

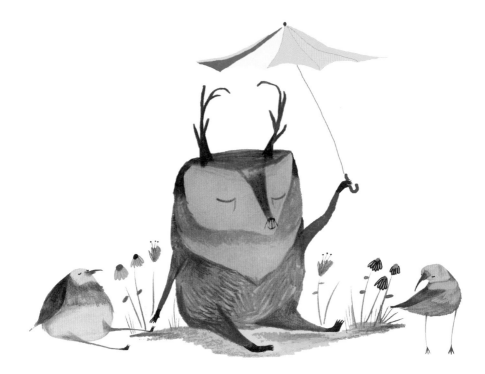

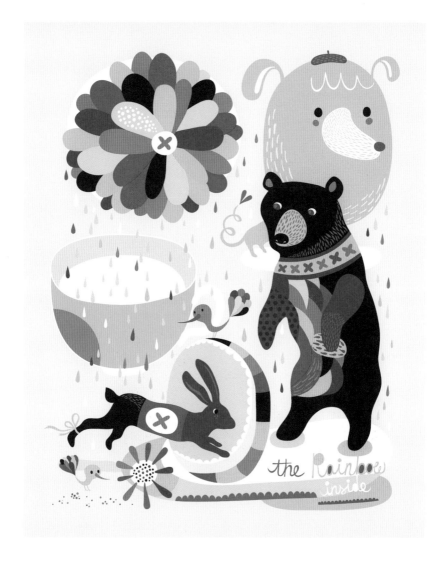

the Rainbow inside

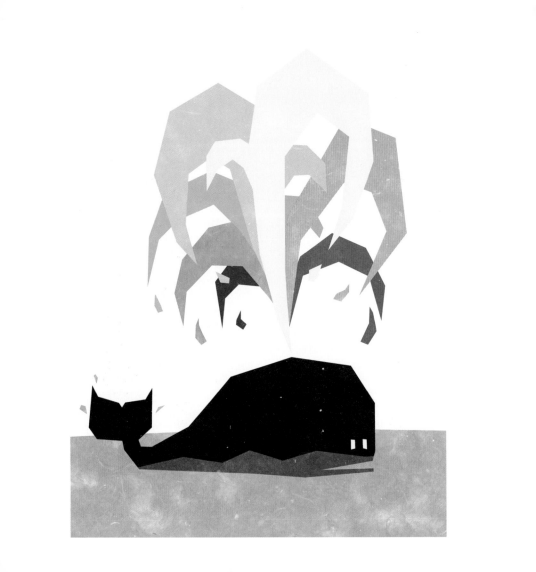

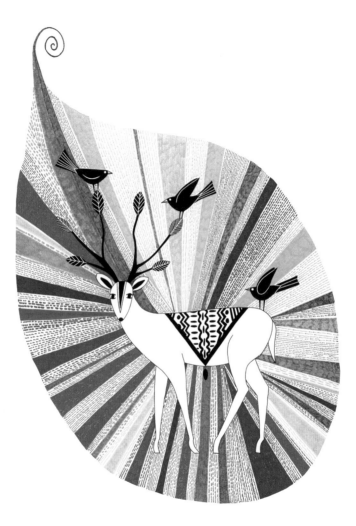

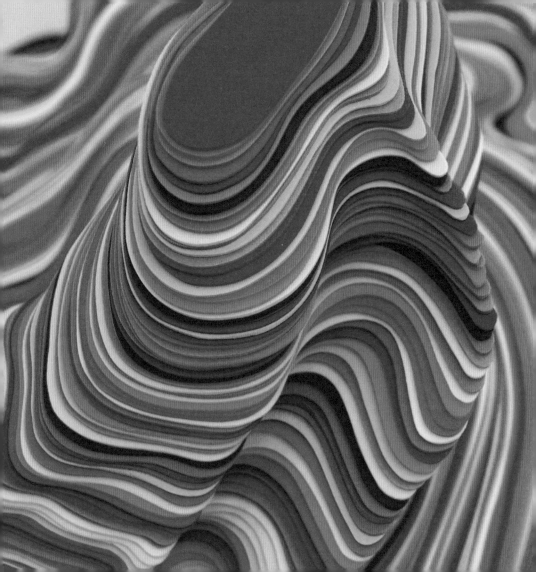

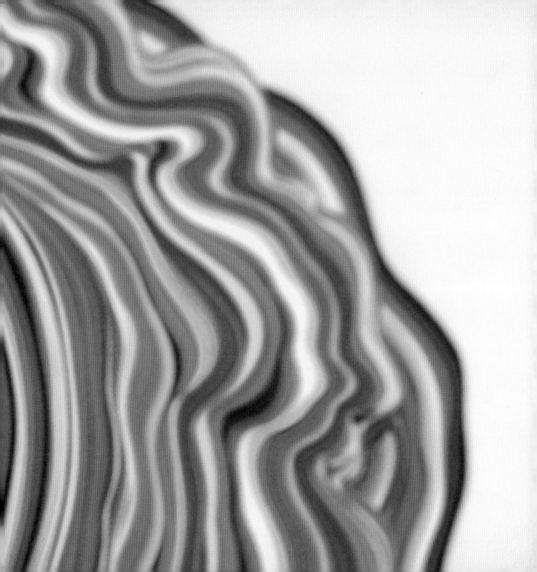

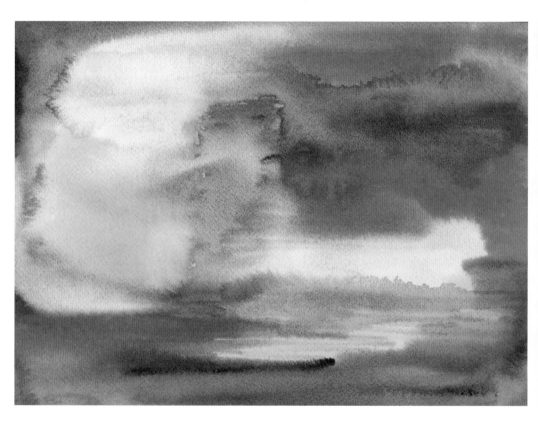

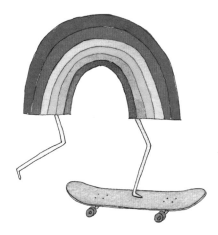

When you come across a rainbow
riding on a skateboard, it's probably
going to be a pretty good day.

marc johns

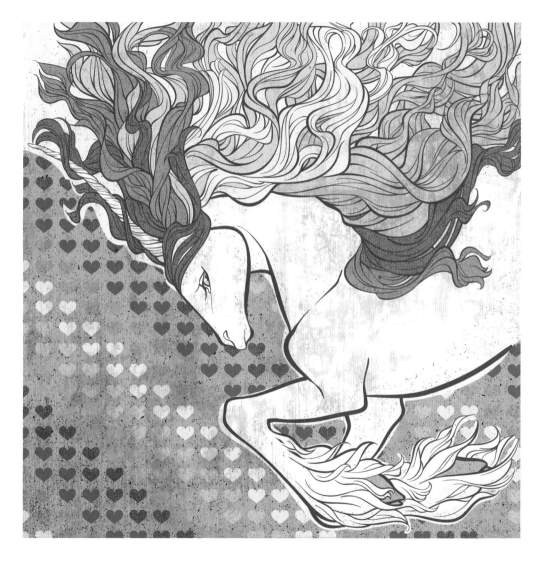

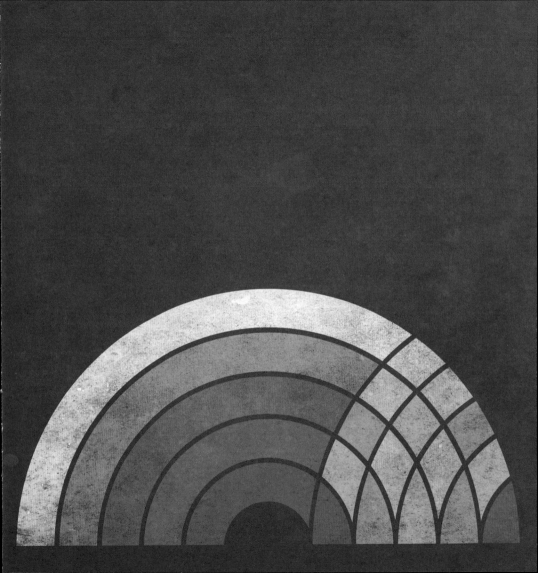

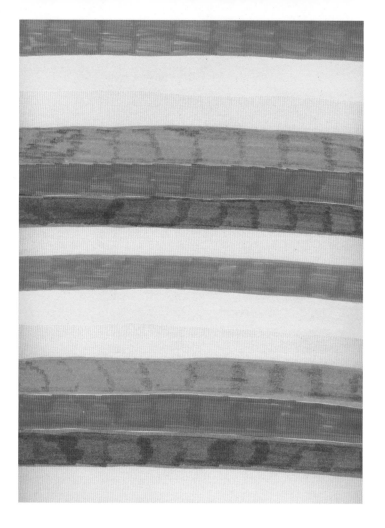

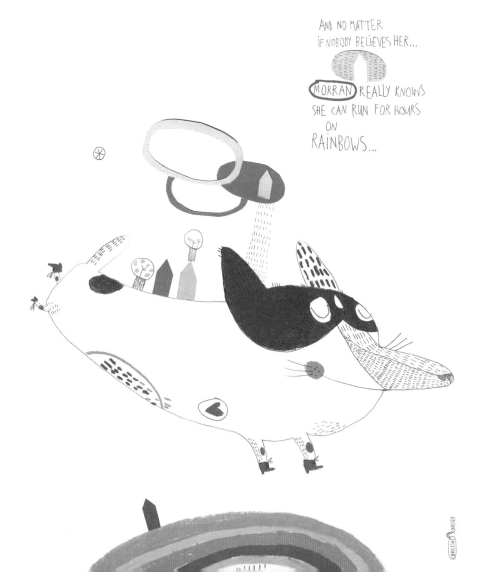

AND NO MATTER
IF NOBODY BELIEVES HER...

MORRAN REALLY KNOWS
SHE CAN RUN FOR HOURS
ON
RAINBOWS...

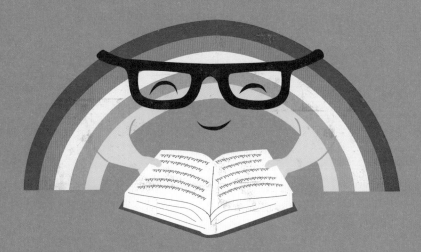

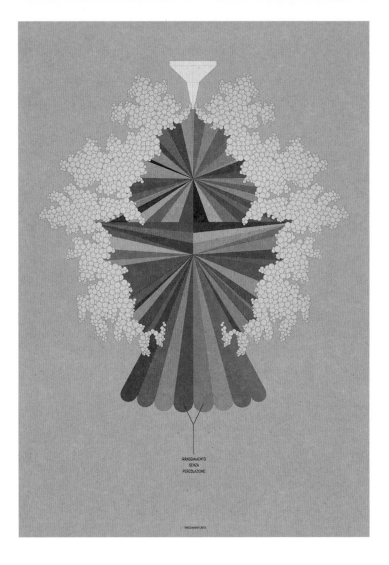

IRRAGGIAMENTO
SENZA
PERCOLAZIONE

TRACCIAMENTI 2013

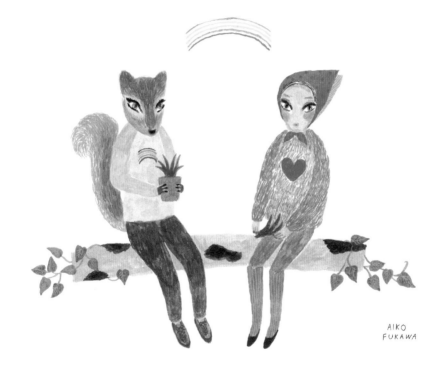

AIKO
FUKAWA

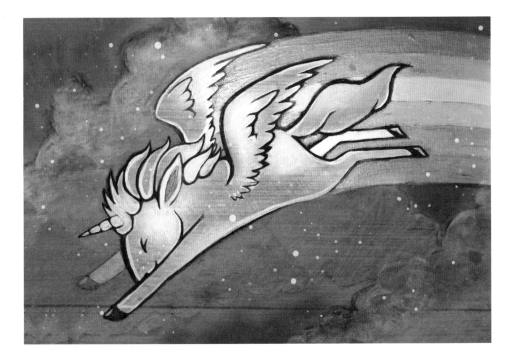

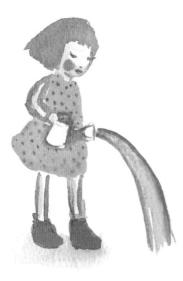

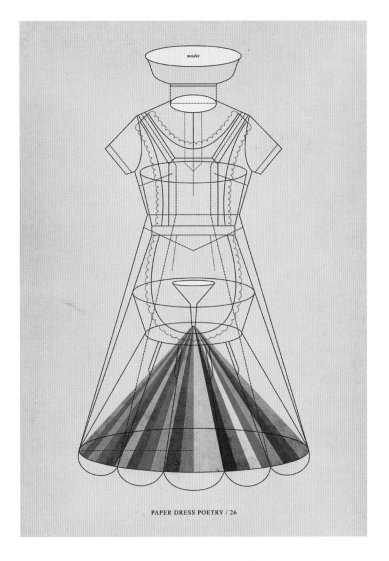

madre

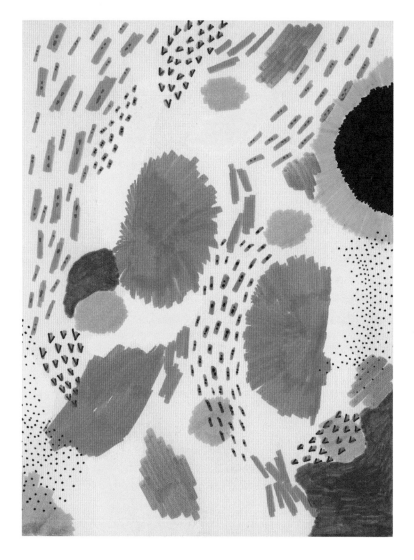

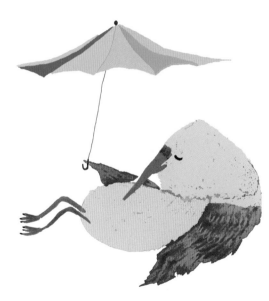

THE OTTAUQUECHEE VALLEY BETWEEN
WOODSTOCK AND RUTLAND, VT.

RAINBOW TYPES

regular

bold

light

italic

extended

condensed

marc johns

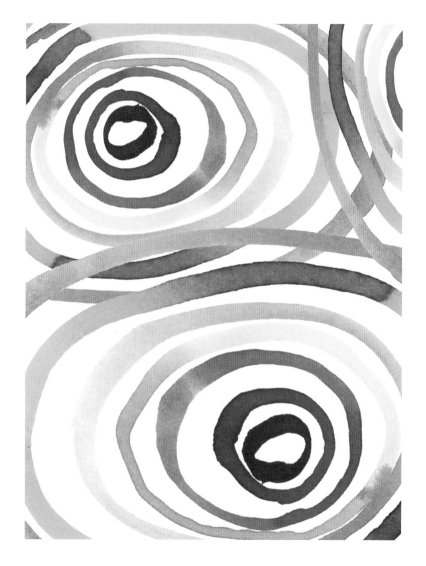

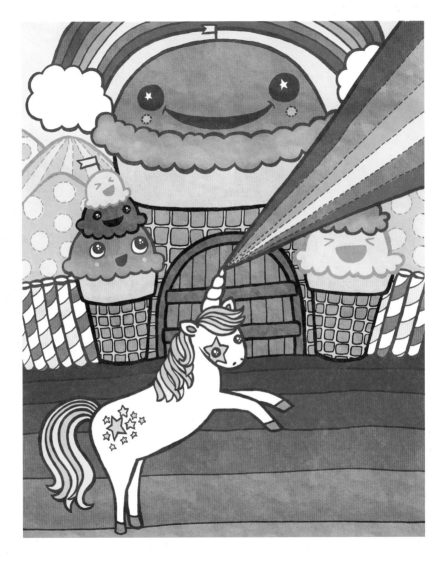

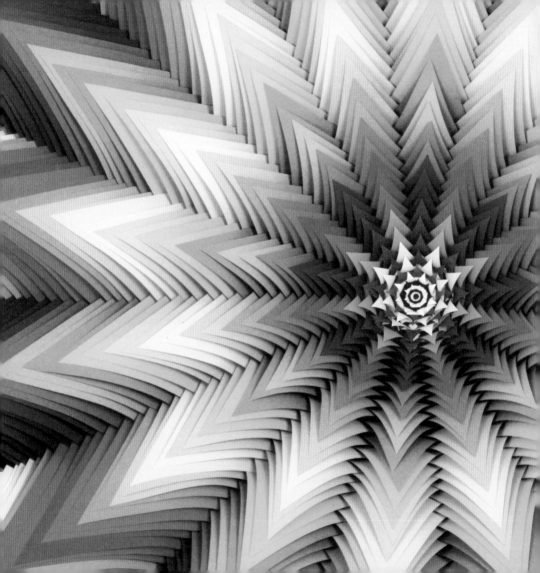

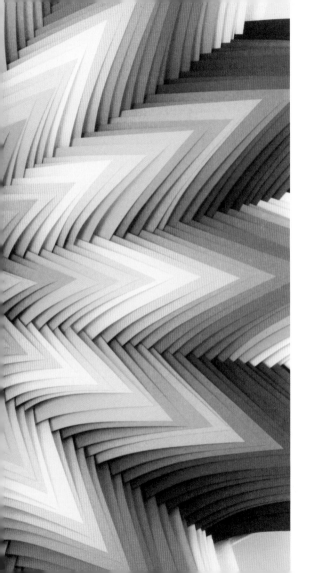

image credits

All images copyright © by the individual artists.

image credits

All images copyright © by the individual artists.

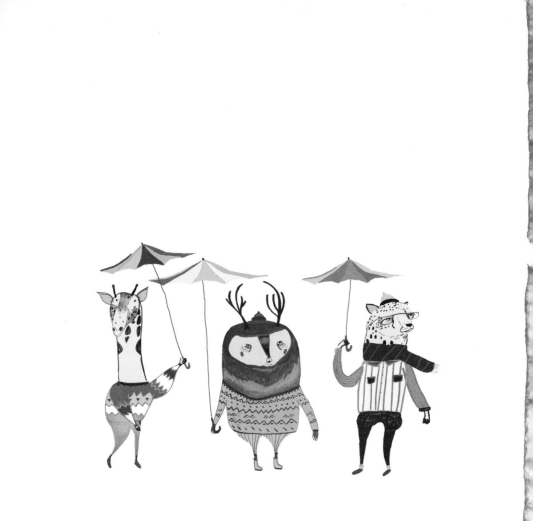